Zentangle is a relaxing and rewarding process that allows all ages to create artistic designs with repetitive patterns (tangles).

Enjoy the experience that tangling brings. Drawing simple tangles can be done anywhere and no 'artistic' talent is needed.

The process helps anyone get in touch with life, solve problems, turn mistakes into positives, be innovative and become more creative.

"Anything is possible, one stroke at a time™".

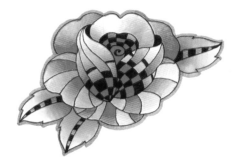

Table of Contents

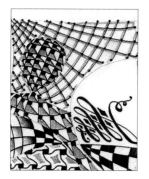

Zentangle®
page 4 - 5

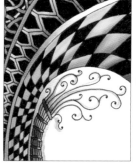

Colored Pens
page 6 - 9

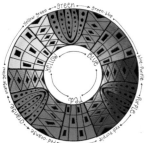

Color Basics
page 10 - 13

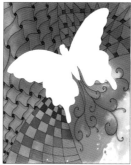

Splash
page 14 - 15

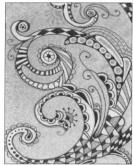

Mask & Spray
page 16 - 18

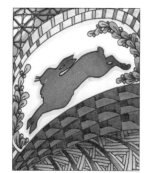

Stamped Images
page 19

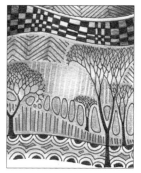

Colored Pencils
page 20 - 21

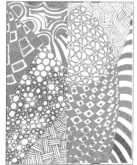

Colored Pens
page 22 - 23

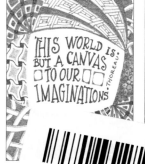

[...]
pag[...]

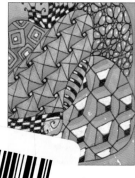

...el Pens
page 25

48 Tangles and Borders are on pages 26 - 41 • The Tangles Index is on page 50

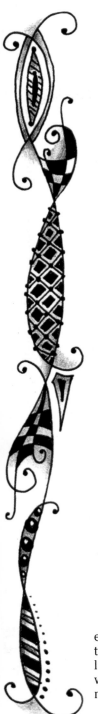

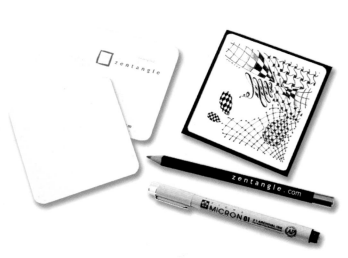

Zentangle calms the mind. It helps reduce stress and improves focus. This relaxing process turns simple patterns into artistic design.

Permanent Pen

My favorite is a permanent *Sakura®* Pigma™ Micron 01 black pigment ink pen.

Pencil

A soft pencil for drawing the strings and for shading.

Paper Tiles

Zentangle's method uses 3½" x 3½" die-cut squares of museum grade Italian print-making paper, called 'tiles'.

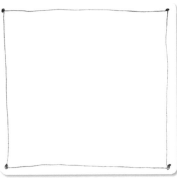

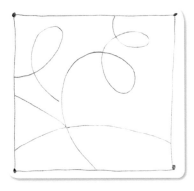

Steps for Zentangle
1. Make Corner Dots

Using a pencil, make a dot in each corner of a tile. Connect the dots to form a border. This line can be wavy or straight. You don't need a ruler.

2. Draw a String

The line can curve, wiggle, zig or zag into any shape you want – try circles, triangles, and other simple shapes.

Make some areas large and others small.

Do not erase. The original pencil lines are part of the design.

3. Add Tangles

Switch to a black Micron pen.

Fill each section with a different tangle (see pages 26 - 41).

Note: You do not have to fill every section with a tangle.

4. Add Shading with a Pencil

I encourage you to experiment with the shading process. Shading adds depth and texture to your design. Shading also adds a touch of dimension.

I suggest that you use a soft 2B pencil

Step 1 - Use the side of a pencil to gently color areas

and details with gray.

Step 2 - Use a 'paper stump' or your finger to rub the pencil areas to smudge, soften and blend the gray shadows.

Note: Use shading sparingly. Be sure to leave some sections white.

Where to Add Shading...

Around the outside edge of a section

In background spaces

On one side of a tangle

Along the right edge and bottom of your finished shape

Make shading about $1/8$" wide, to 'raise' tangles off the page.

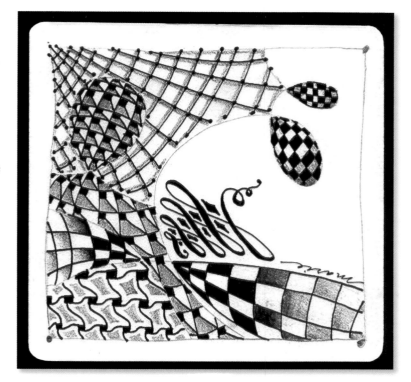

5. Sign Your Art

Put your initials or signature on the front.
Put your name on the back with the title and date.

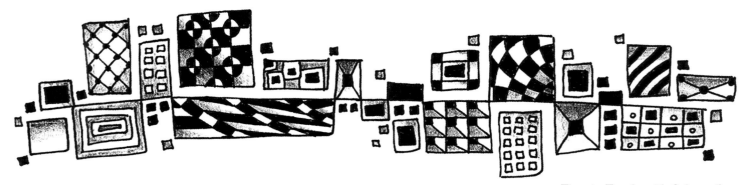

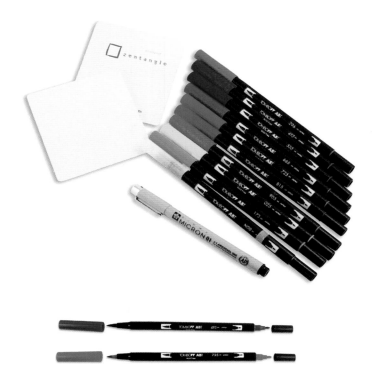

Additional Materials

Dual Tip Brush Markers

I use *Tombow* Dual Brush Markers and a colorless blender to color and shade.

Plastic Blending Palette

A $5\frac{1}{2}$" x $8\frac{1}{2}$" clear transparency sheet taped to a piece of White paper works well.

The White paper helps me see the colors clearly.

Paper Tiles and Squares

A Zentangle tile $3\frac{1}{2}$" x $3\frac{1}{2}$" is preferred. It is smooth Italian art paper that is easy to draw on and easy to color (zentangle.com).

This size is easy to carry, small enough to carry in a bag, small enough to complete a project at one sitting, and is able to be combined in a mosaic of tiles.

Tombow Dual Brush Markers - Brush on one end, Point on one end

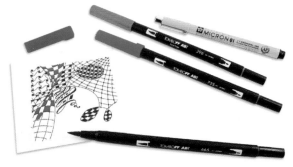

Bring Tangles to Life with Color

Color brings my work to life, adds excitement and satisfies my addiction to color.

Classic Zentangle drawings resemble delicate etchings, but I love to color my designs. Inspired by the simplicity and beauty of Zentangle, I add color and shaded colors on top of the Micron permanent black ink drawing.

As an option to shading with pencils, I prefer to use Tombow Dual Brush Markers and a blending pen to shade and blend the colors into my designs.

Steps for Coloring

Draw a Zentangle

Create a Zentangle (pages 4 - 5) but do not add any pencil shading.

Direct Coloring

Color areas on the tile with Dual Brush Markers. Use the pen at full strength to add color.

Choose a large selection of colors that include dark, medium and light hues.

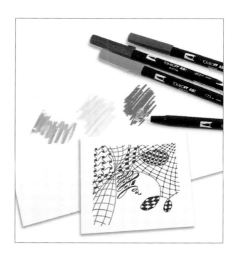

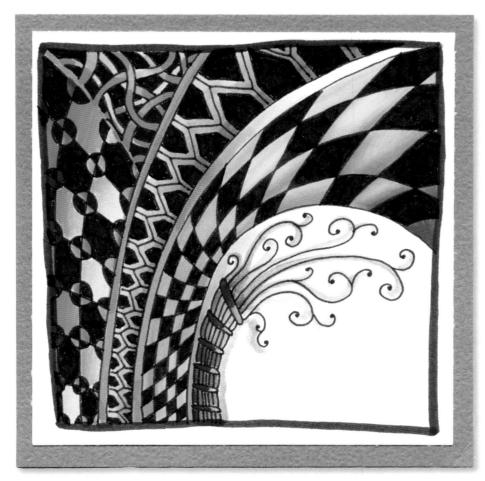

Indirect Coloring

Stroke the colors onto your plastic palette using the brush tip until you have 1" - 2" diameter of color on the palette. The color does not dry on the slick plastic surface.

Use the blender pen like a paintbrush. Pick up the color from the palette with the brush point.

Start applying color where you want the darkest shades. Continue until the design is completely colored or the color has faded to clear.

Work in small areas at a time and do not overblend. Keep the pen on the paper while shading and try to resist the temptation to go back and correct the middle of a blend.

This coloring method makes it easy to shade the color from dark to light and to mix colors by layering one color over another.

TIPS: Let the first color dry before adding a second color on top. Do not overwork the coloring as it may start to 'pill' the paper. Using a smooth watercolor paper prevents 'pilling'.

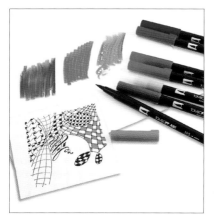

Brush Blending

Place dark colors onto a palette. Run a lighter colored Dual Brush Marker through the color on the palette.

The colors will magically blend as you stroke the marker across the paper and you can make several strokes with just one load of color.

The amount of color you pick up can vary to give you a variety of blended intensities. Use this technique when making the strokes in colored tangles.

To clean the brush tip, simply scribble the color out on a piece of scrap paper until it returns to the original color.

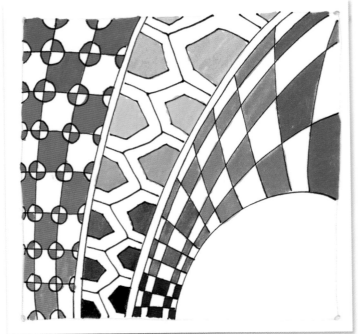

Direct Coloring

Remember the excitement of opening a new box of crayons? Unleash your inner child and get out your markers. It's time to rediscover the joys of coloring. Pick a bouquet of pens and relax as you color in the spaces... and, yes, it's still a good idea to stay within the lines.

I used 16 Dual Brush Markers in various shades to make this tangle. I chose areas and began coloring.

I planned the colors so they would flow from hot (red) to cool (blue) across the design.

I like the way the spaces expand from compact at the bottom to wide open at the top.

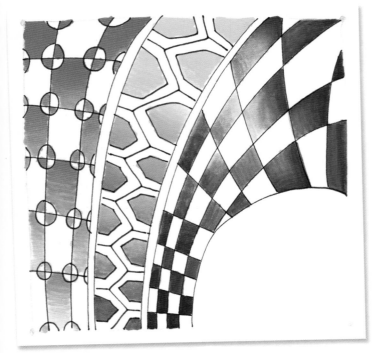

Indirect Coloring
with Brush Blending

If your design requires fading from one color to the next, this technique is just right for you. Scribble some ink onto a palette and pick it up with your blender pen. As you color, the ink will run out of the pen, causing a natural fading. Try this.

It's fun and easy.

I used 7 colored Dual Brush Markers, a blending pen and a plastic blending palette to create this design.

The brush blending technique allows the colors to fade as you go, creating automatic shading.

Borders

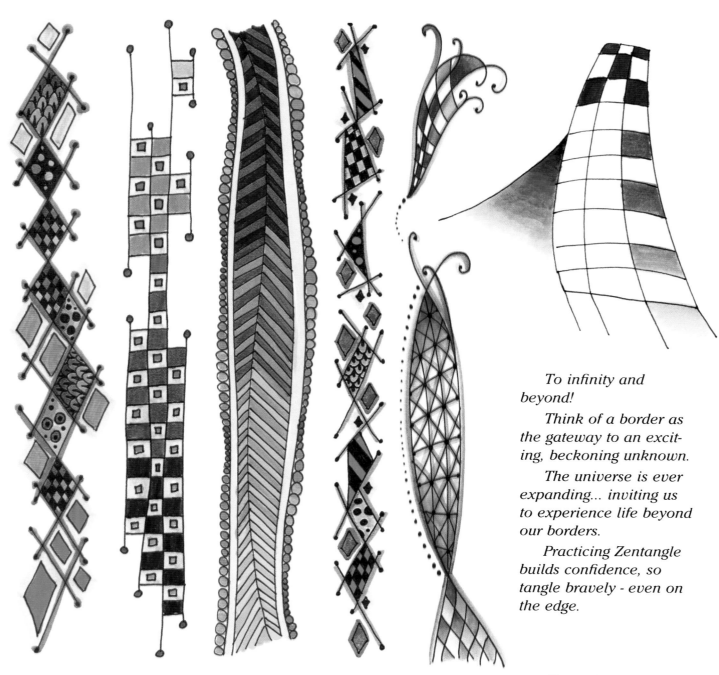

To infinity and beyond!

Think of a border as the gateway to an exciting, beckoning unknown.

The universe is ever expanding... inviting us to experience life beyond our borders.

Practicing Zentangle builds confidence, so tangle bravely - even on the edge.

Color Basics

The human eye can detect about six million different colors, so deciding what you want when coloring tangles, and narrowing your choice down to a color scheme still leaves you with millions of variations to choose from. It's important to understand a few basics about color to help you make choices that create a harmonious finished piece.

A color chart showing the Tombow Dual Brush Marker numbers is below.

Colors of Dual Brush Markers

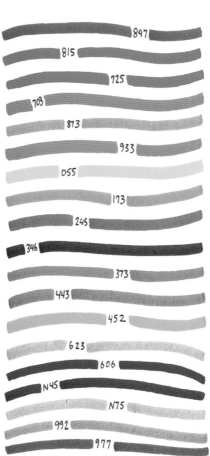

847
815
725
703
873
933
055
173
245
346
373
443
452
623
606
N45
N75
992
977

The Color Wheel

Primary Colors - Red, Yellow and Blue are called primary colors because they cannot be mixed from other colors. All other colors are derived from these three hues.

Secondary Colors
Orange, Green, Purple
Primary colors in equal parts are mixed to form this second tier of color.

Red + Yellow = Orange
Yellow + Blue = Green
Blue + Red = Purple

Tertiary Colors
Mixing 1 primary and 1 secondary color together makes these hues. Examples include Yellow/Green, Blue/Green, and Blue/Purple.

Tints, Tones & Shades
To add further nuance, all colors can then be tinted by adding White, toned by adding Gray or shaded by adding Black.

Harmony is pleasing to the eye because it is engaging and balanced. When something is not harmonious, it's either boring or chaotic. The human brain rejects what it cannot organize.

Color harmony delivers visual interest and a sense of order.

The Language of Color

Knowing the definition of words used to describe color will help you organize your color preferences and schemes more easily. Here is some simple color terminology to keep in mind when talking about color.

Hue is another name for color - Red, Green, Yellow, etc.

Value describes the darkness or lightness of a color. A color light in value has been diluted with White. For example, Pink is a tint of Red and has a light value. A dark value color is closer to Black on the scale, because Black has been added. For example Burgundy is a shade of Red with a dark value.

Chroma refers to the intensity of a color - how bright or dull it is. Scarlet and Brick Red are similar in value, but their intensity differs. Brick Red is duller and has a lower chroma than Scarlet. Scarlet has a higher chroma so is more brilliant. Colors with high chroma are more pure.

Temperatures

Cool colors tend to have a calming effect. Blue, Green, and the neutrals White, Gray, and Silver are cool colors.

Warm colors convey emotions, such as excitement or passion. Red, Yellow, Pink, and Orange are warm colors.

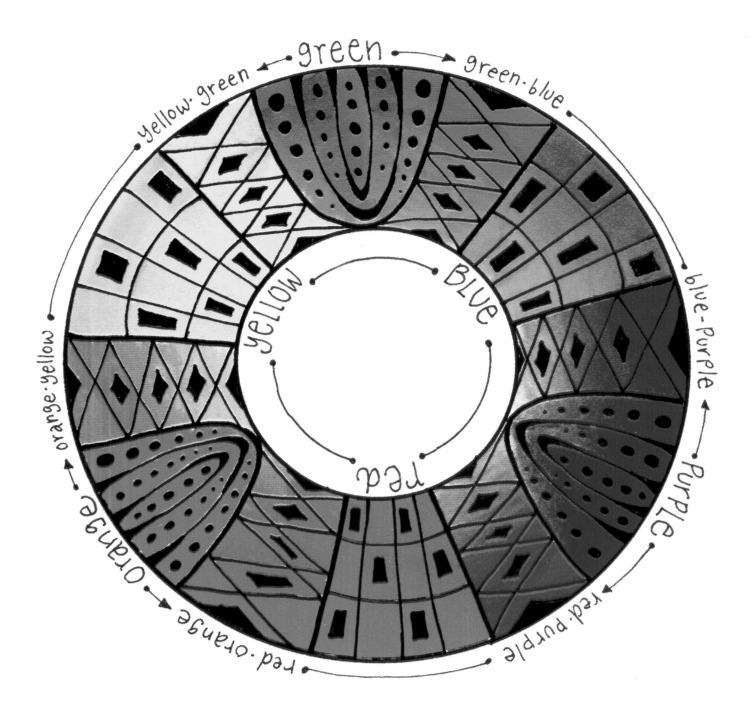

Color Schemes

Knowing how to work with the four basic color schemes will make your art look professional and appealing.

For a clean design, try a monochromatic theme.

Neutrals are very organic when applied to curved spaces but they can also look very industrial when applied to sharply drawn graphics.

Analogous schemes are soothing while complementary schemes create contrast.

Monochromatic

These schemes use tints or shades of the same hue and are the easiest to start with. Use different Blue colors for a serene design.

Analogous

Any three colors that are side-by-side on the color wheel will always look good together; for example, Yellow/Green, Green, Green/Blue.

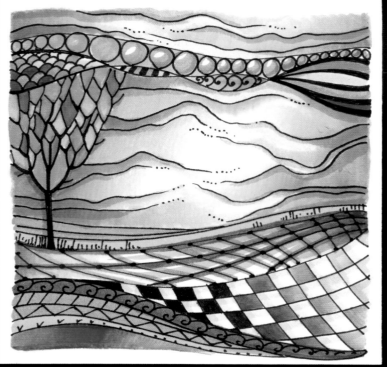

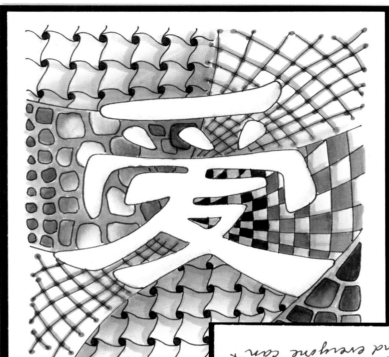

Complementary

Any two colors which are directly opposite each other on the color wheel are complementary. Color complements provide contrast.

Each warm color has a cool color as its complement. Complements create visual excitement and draw attention.

This sample uses Reds and Greens to create a balanced and pleasing color scheme.

Neutral

Black, White, Browns, and Grays are neutral colors.

Traditional Black and White designs with shading are examples of a neutral color scheme.

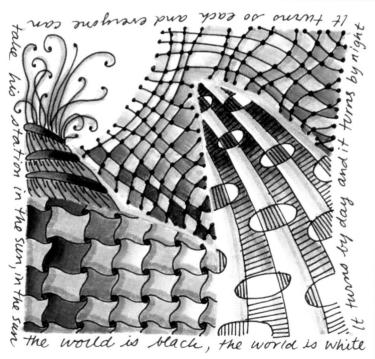

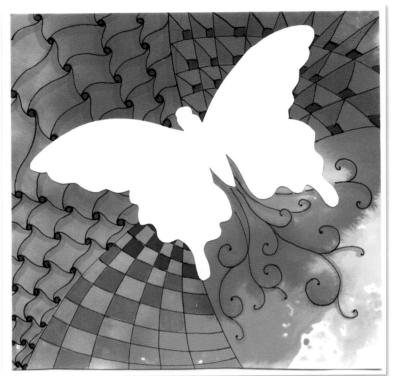

Splash Backgrounds

Are you up for a surprise? Splash techniques produce unpredictable, exciting and unique backgrounds for your favorite tangles.

Every background produces a one-of-a-kind result. Try this next time you want something really special.

Butterfly

You can also create a colored Zentangle and add a cut-out image or die-cut shape. Simply secure a shape on top of the paper before you press it into the color, rub and lift. Remove the shape after the ink dries.

Many simple die-cut shapes, template shapes, and shape cutting tools are available at your local craft or scrapbook store.

1. Apply Ink to a Palette
Cover a plastic transparency palette with ink from Dual Brush Markers.

2. Spritz with Water
Spritz the plastic palette with water.

3. Press the Paper
Press the paper face down into the color, rub and lift. Let the colors dry completely. Repeat if desired.

Splash Background Palette

I use a full 8½" x 11" clear plastic transparency sheet for larger designs. Keep some paper towels handy for wiping the palette clean.

Splash Background

1. Cover a plastic palette with ink from your Dual Brush Markers.
2. Spritz the palette with water.
3. Press the paper face down into the color, rub and lift. Let the colors dry completely. Repeat if necessary.
4. You can also mist the paper with water or add additional colors after it dries to create a variety of beautiful mottled backgrounds.

Salty-Splash Background

5. After lifting the paper from the wet palette, sprinkle table salt or coarse salt on the wet surface of the paper.
6. Do not disturb until it is completely dry.
7. Brush off the salt to reveal a beautiful mottled coloring.

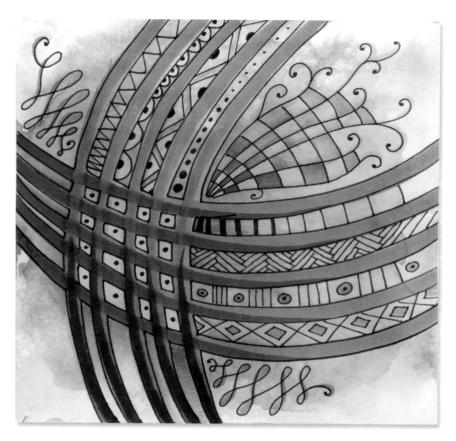

Simple Splash

Simple Splash
with Additional Color

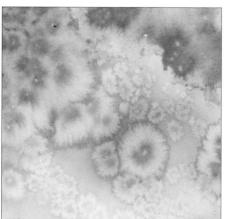

Salty Splash

Mask and Spray Technique

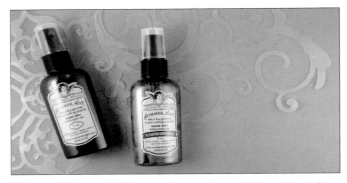

Glimmer Mists and Glimmer Screens from *Tattered Angels*

This technique uses the wonderful colored glittery Glimmer Mist sprays and Glimmer Screens (stencils) to color the paper and create your 'strings' before drawing tangles.

It works well with coloring the tangles with markers. You can use the stencil screens to mask the paper when spraying.

Use light mists, overlapping different colors until you are happy with the effect.

Step 1: Use smooth white cardstock and place the screens on top of the paper. There is no need to tape down the mask.

Step 2: Shake the Glimmer Mist spray by shaking sideways (this helps to keep the nozzle from clogging). Spray lightly.

Step 3: Carefully pick up the screen and place it in a different location on the paper, or overlap the previous screen. Spray lightly with the same or a different color.

Step 4: Remove the screen and spray lightly with the same or a different color. Let the Glimmer Mist spray dry completely before drawing tangles with a Micron black pen.

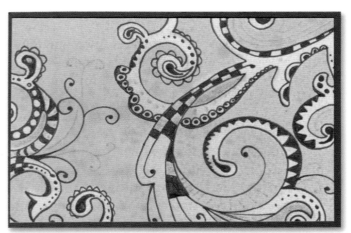

A sepia toned 'Mask and Spray'.

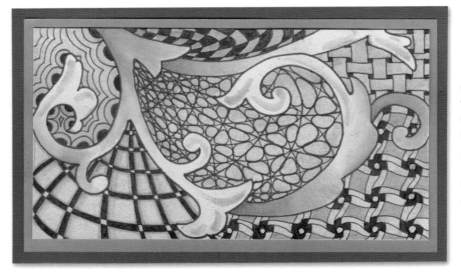

After the Glimmer Mist spray dries, outline the masked design with a Micron black pen. You can then choose to tangle between the designs or tangle inside of the designs as these samples illustrate.

Tip: The tangles around the 'string' designs have been colored with Dual Brush Markers.

Your focus determines your reality. Zentangle helps you learn to let go of your expectations, be still and listen to your design. When you allow the design to speak to you, you will tap an infinite source of creative energy.

Your tangles become easy, as though they flow through you rather than from you. Beauty unimagined will flourish and you will experience bliss as you create.

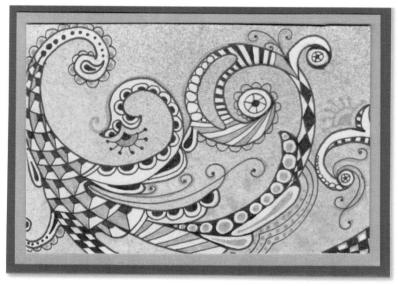

Samples Using the Mask and Spray Technique:

Use Glimmer Mist gold spray, a Micron black pen and Dual Brush Markers. A simple two-colored color scheme was used.

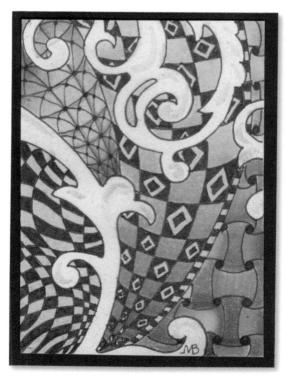 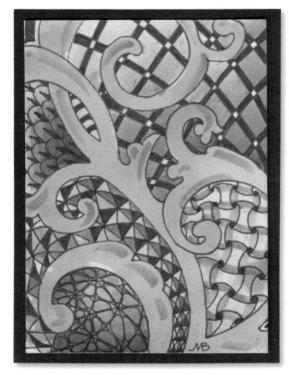

Mask and Spray Technique with Alphabet Stickers

This variation of the Mask and Spray technique uses alphabet stickers as the mask.

Create personalized cards and messages. It is also perfect for making signs for your office or as an inspiration word.

Place stickers onto a smooth sheet of white cardstock without pressing them down. Tip: Most stickers come off easily after spraying lightly with the Glimmer Mist spray and do not leave a sticky residue.

TIP: It is best to test the sticker first to make sure it does not tear the paper when lifting off. After spraying do not 'quick dry' the paper with a heat tool or hair blower - this will leave sticker glue on the paper.

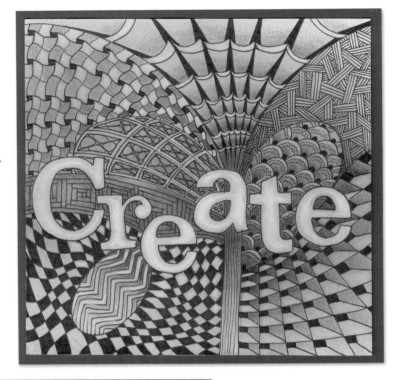

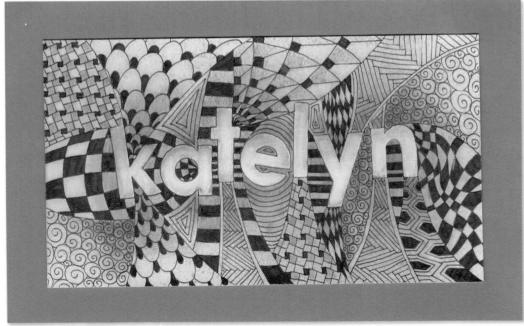

Both samples were done on smooth white cardstock using light green and light blue Glimmer Mist spray over alphabet stickers.

The tangles were drawn with a black Micron pen and colored with colored pencils.

The 'Create' sign was colored with a white pencil to add the highlights on the design and in the letters.

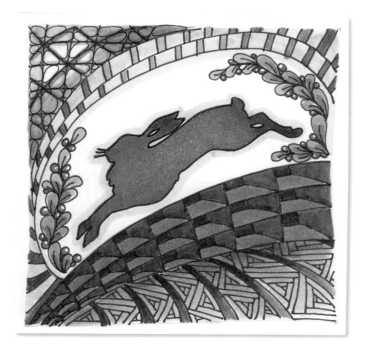

Stamped Image Technique

This technique is a nice way to inspire a Zentangle design. Simply use a colored inkpad and stamp your image onto smooth white cardstock.

The samples show the stamped image with tangles drawn around it.

Rabbit Card

For this design, I chose to outline the stamped rabbit with a Micron black pen and color the tangles with Dual Brush Markers.

Notice the red colored berries give the design a nice complementary color scheme and the light blue pen with a 'halo' around the rabbit softens the image.

An Artist Card

This card design started with a colorful splash background in purple, pink and blue.

Ink the rabbit rubber stamp with the brush point of a light colored marker and then stamped onto the paper.

Use a pencil to add the strings. Outline the stamped rabbit and draw tangles around the rabbit with a Micron black pen.

Additional colors and the words were added with colored Dual Brush Markers.

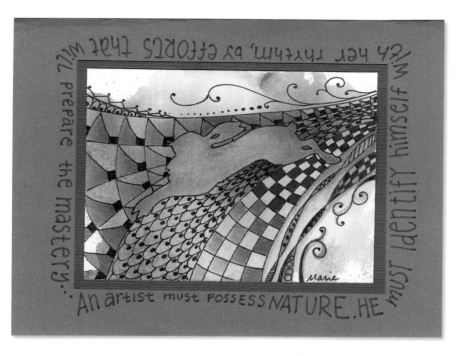

Colored Pencil Technique

Using colored pencils to color your Zentangles is the easiest coloring technique. Use simple colored pencils, but remember that top quality pencils are easier to color with and give your drawing archival qualities.

Sample 1 -

With all coloring, you can choose to color the whole tangle by shading along the edges of the string. I also use a technique called 'haloing' where you just highlight the Micron black pen lines with a line of color.

Sample 2 -

Color each individual area within the tangle.

It usually depends on each individual tangle as to which method you choose, and of course, you can combine the methods - either way, there's no wrong way.

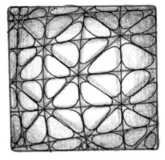
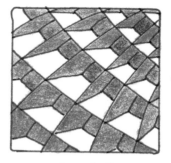

Sample 1 Sample 2

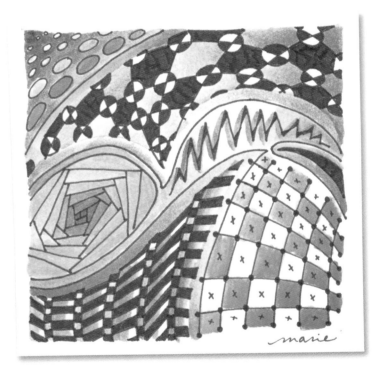

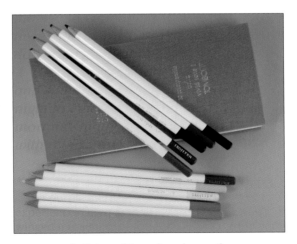

Artist quality colored pencils.
Tombow Irojiten Colored Pencils

Shading on Rough

Broad shading is the colored pencil technique you will use to shade the tangles. Working just like a graphite pencil, add pressure to darken the color. It is best to add the color in layers. Start with light shading and gradually work up to darker shades.

This shaded sample is done on 140# cold press watercolor paper. This surface has a rough texture that creates a texture when shaded.

Shading on Smooth

This broad shading sample shows the difference when working on smoother paper. A Zentangle tile was used for this sample.

A great hint for smoothing or blending colored pencils is to use a colorless blender pen. (the same blender pen used with the colored marker technique).

Layers

It's important to remember to add color in layers when shading one color into the next.

Four colored pencils were used in this sample - dark red, red, orange and yellow - on a smooth Zentangle tile.

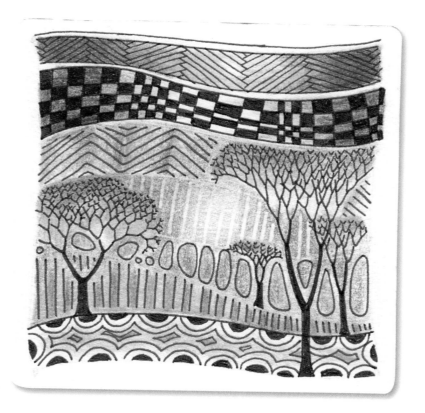

Finish with colored pencils in a fall color scheme.

Impressed Technique

The 'impressed' technique works wonderfully on the soft smooth surface of Zentangle tiles (and also on heavy 140# watercolor papers).

Simply use an embossing tool (or a ballpoint pen that has run out of ink). Before you add color, impress your drawing into the paper using a heavy hand. Add shading with light or dark colors and the impressed lines will stay white.

Embossing tool

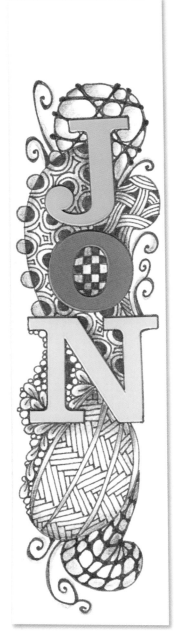

Start these Zentangle-inspired bookmarks with colored alphabet stickers. Use a pencil to draw around the letters to make a 'string' in the center of a smooth cardstock bookmark. Draw tangles with Micron colored pens and shade with colored pencils or Dual Brush Markers.

These Monochromatic colors worked out nicely on smooth cardstock.

Seeing your name beautifully embellished by a caring hand makes you feel loved.

Make someone's day special by giving a simple bookmark. Unlike a card, they will use a bookmark every day and every time they pick up their favorite book, they will smile and think of you.

Decorate a special person's name in wonderful colors and gorgeous tangles.

Colored Pens Technique

Permanent colored pens are a great way to make colorful tangles. Instead of a Micron black pen, pick up a Sakura Micron permanent ink color pen.

I prefer to work with 'permanent ink' pens so I have no accidental bleeding of colors when I use Tombow (waterbase) or Copic (alcohol) marker techniques on top.

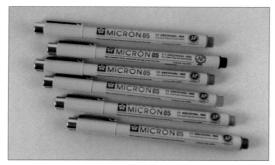

Sakura Micron color pens

Sharpie colored pens

Colored Bookmark

This Zentangle bookmark (to the right) used only Micron colored pens. Mixing the colors within a tangle gives the colors punch. Make sure the colors work together in your colorful rainbow color scheme.

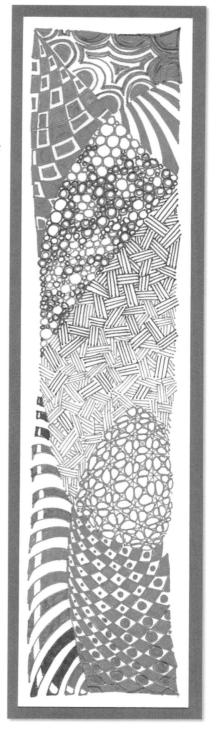

Sparkle Gel Pens Technique

Adding bling to your tangle creations is easy when you use sparkly Sakura Stardust Gelly Roll pens. Simply color in the tangles with solid coloring or use the gel pens to draw some of the lines.

Stardust Gel pens also work nicely on black cardstock or for drawing over black areas.

Sakura Stardust Gelly Roll color pens

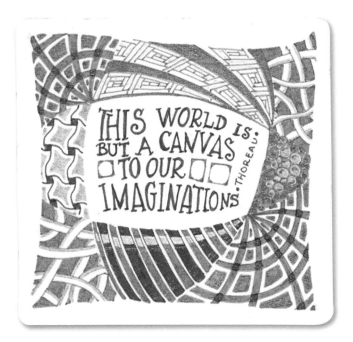

This sample used a *Sakura* Micron black pen and *Sakura* Stardust Gelly Roll color pens in an analogous color scheme.

Sakura Micron black and color pens were used to draw the tangles and then colored in with matching *Sakura* Stardust Gelly Roll color pens.

Splash Background and White Gel Pen Technique

Sakura white Gel pen and *Ranger* Inkssentials white pen

When drawing on a colored background such as the splash background or mask and spray background, an effective technique is to color the white highlights.

When working with colored pencils, simply use a white pencil.

When working with markers, a white gel pen works nicely to cover the color and add white to the design.

Both samples are *Sakura* Micron black pen on a salty splash background, colored with Dual Brush Markers and a white Gel pen.

Time to Tangle

Many of the tangles in this book are new, some are variations of my favorite original patterns. For example, the first tangle is a simple grid... just one variation.

It illustrates the endless variations you can create when learning a new tangle. Use your imagination and play with tangles to create your own unique variations.

Just one of the benefits of Zentangle (there are many!) is that you start to see the world around you with a new perspective.

You begin to notice patterns and color combinations that you normally never noticed – adding richness to your everyday existence.

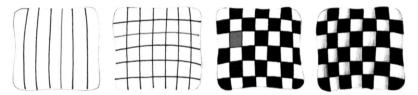

Knightsbridge – an original Zentangle design

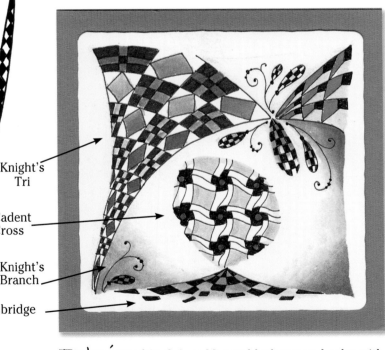

Knight's Tri

Cadent Cross

Knight's Branch

Knightsbridge

Techniques: *Sakura* Micron black pen and color with *Tombow* Dual Brush Markers using direct and indirect coloring
Color Scheme: Turquoise and grey

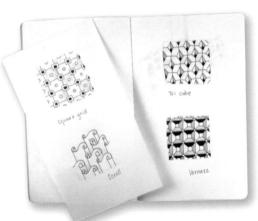

Inspiration from Italy

The trip my husband and I made to Italy for our 25th wedding anniversary was inspiring. I filled a sketchbook with new tangles and sketches. Just looking at these beautiful marbled marvels was amazing!

A marbled church floor in Italy inspired these tangles. These inlay floors with bold geometric designs are called Cosmati Mosaics, named for a family from the 12th Century. The original designs can still be seen when touring the churches.

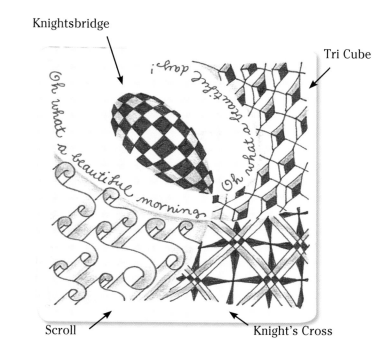

Knightsbridge

Tri Cube

Oh what a beautiful morning

Oh what a beautiful day!

Scroll

Knight's Cross

Techniques: Colored pen, Colored pencil to shade
Color Scheme: Purple Monochromatic

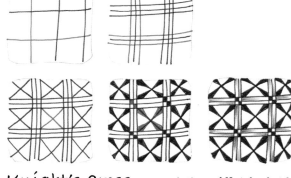

Knight's Cross – a variation of Knightsbridge

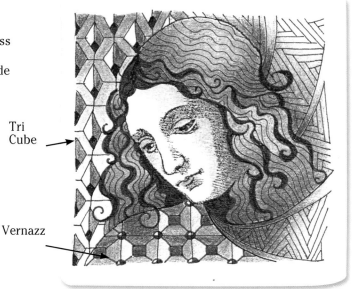

Tri Cube

Vernazz

Techniques: Stamped image,
Micron black pen, Use colored pencils to shade
Color Scheme: Neutral browns and sepia
for the image, Blue, purple and red background,
Analogous color scheme

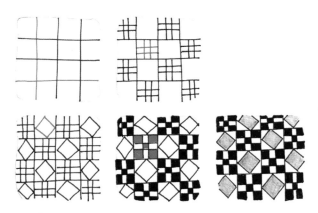

Knight's Tri – a variation of Knightsbridge

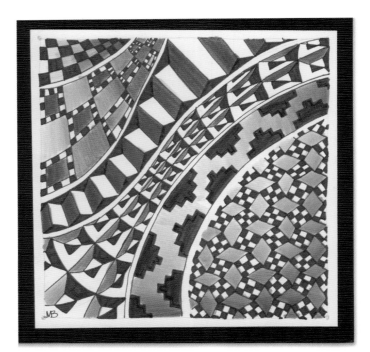

Sepia Tones
(A New Color Scheme)

Sepia colors make a nice color scheme for beginners. Sepia can be created with all the coloring techniques in this book.

Techniques: *Sakura* Micron black, brown and sepia pens on smooth white cardstock. Color the tangles with the Micron pens and with sepia Dual Brush Markers.

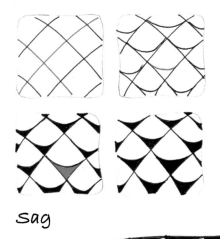

Sag

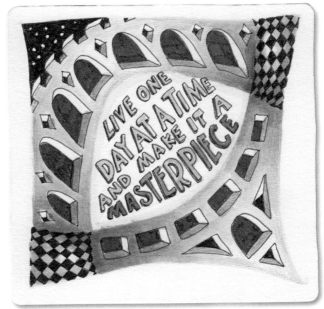

Use a Micron black pen to draw the design. Add colors with sepia Dual Brush Markers. Create an unexpected light blue 'halo' to frame the lettered section and make it 'pop'.

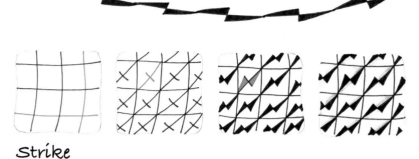

Strike

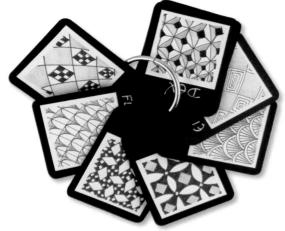

Tangle Tags – Make a practice set of tangles. Keep them on tags as a ready reference.

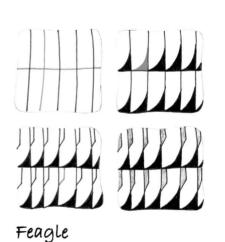

Feagle

Inspiration from Native American Pottery

These tangles were inspired by traditional designs found on Native American pottery.

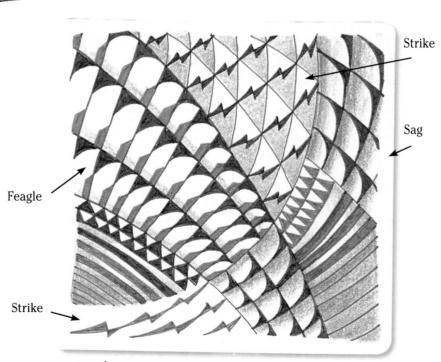

Strike

Sag

Feagle

Strike

Techniques: *Sakura* Micron black, brown and sepia pens, Use colored pencils to add shading
Color Scheme: Sepia

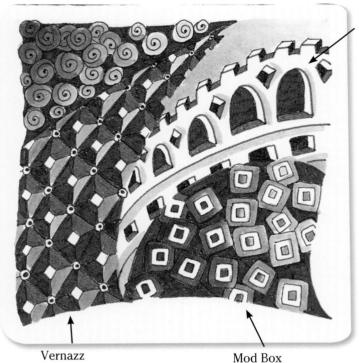

Skistel

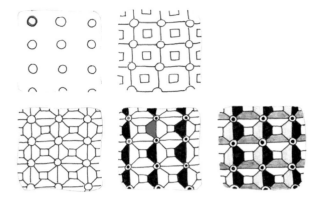

Vernazz - a variation of Cubine

Vernazz

Mod Box

Techniques: *Sakura* Micron black and sepia pens, Add colors and a halo with Dual Brush Markers using direct and indirect coloring

Color Scheme: Blue and sepia

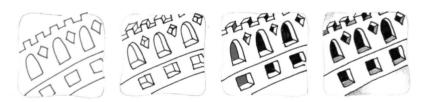

Skistel - this name is a combination of 'sky' and 'castle'.

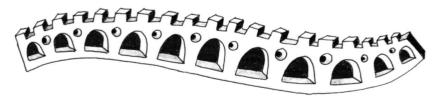

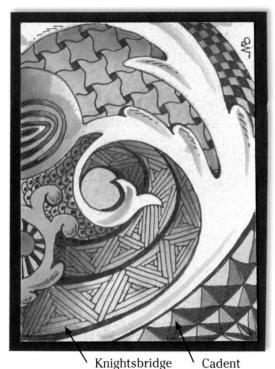

Knightsbridge Cadent

Techniques: Glimmer Mist spray and Glimmer Screen stencil, Micron black pen, Dual Brush Markers using direct and indirect coloring

Color Scheme: Brown and red

Inspiration from Italy

These tangles were inspired by marbled floor designs in a church in Siena, Italy.

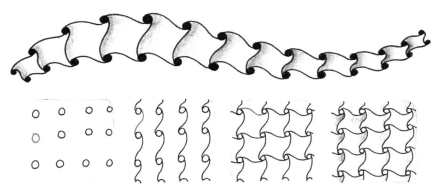

Cadent - an original Zentangle tangle

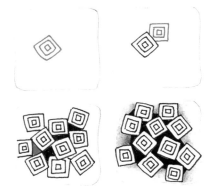

Mod Box

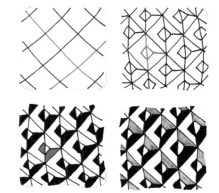

Inlay - a variation of Cubine

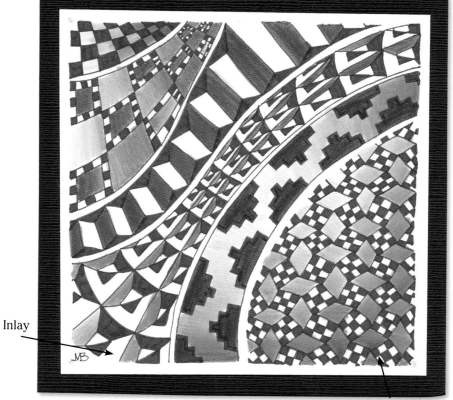

Inlay

Knightsbridge

Techniques: *Sakura* Micron black, brown and sepia pens,
Add colors with Dual Brush Markers using indirect coloring to add shading
Color Scheme: Sepia

Knightsbridge Nzeppel Knight's Branch Squish

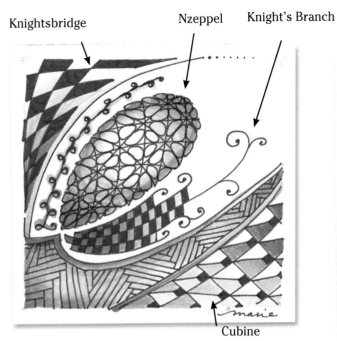

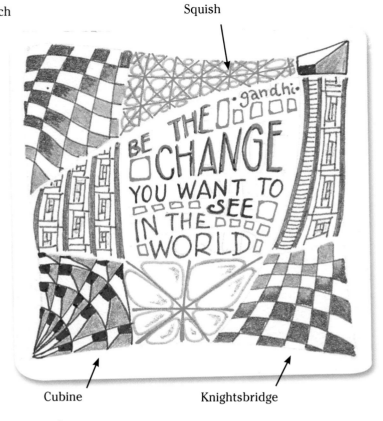

Cubine

Techniques: *Sakura* Micron black pen, Add colors and a halo with Dual Brush Markers using direct and indirect coloring

Color Scheme: Red, purple, orange and pink

Cubine Knightsbridge

Techniques: Colored pens, *Sakura* Stardust Gelly Roll pens

Color Scheme: Purple, blue, pink and red

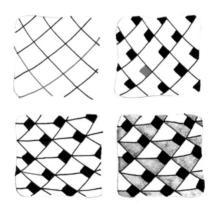

Cubine - an original Zentangle tangle

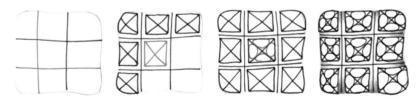

Squish - a variation of Nzeppel

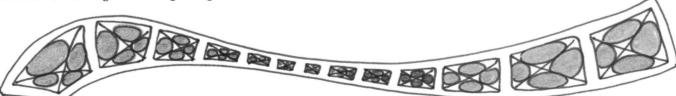

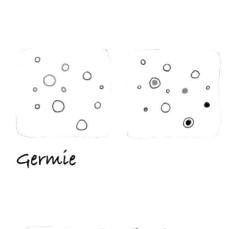

Germie

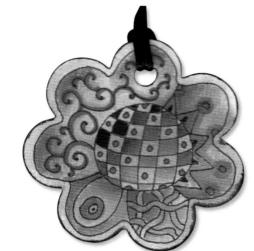

Use Dual Brush Markers to add a pink wash of color on a cardstock shape. Draw tangles with a *Sakura* Micron black pen. Use Dual Brush Markers to highlight the tangles with bright colors.

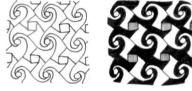

Cadent Swirl - a variation of Cadent

Cadent

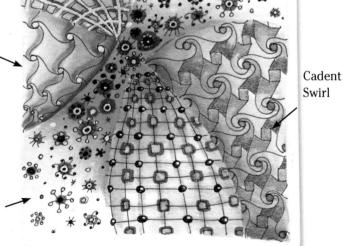

Cadent
Swirl

Germie

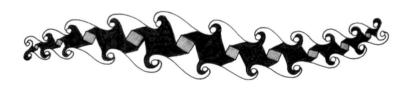

 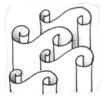

Scroll

Techniques: *Sakura* Micron black pen,
Stardust Gelly Roll pens blended with a colorless blender,
Add color with Brush pens using indirect coloring to shade

Color Scheme: Blue, purple and pink Analogous

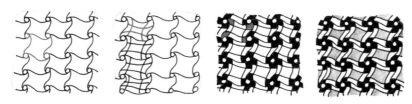

Cadent Cross - a variation of Cadent

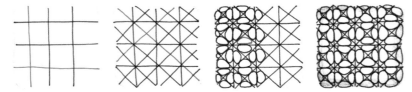

Nzeppel - an original Zentangle tangle

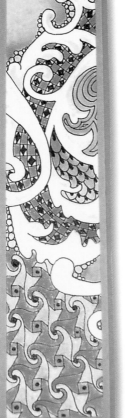

Bookmark Techniques:

Glimmer Mist spray and Glimmer Screen stencil, *Sakura* Micron black pen, Add color with Dual Brush Markers using indirect coloring to shade

Color Scheme:

Blue and green Analogous

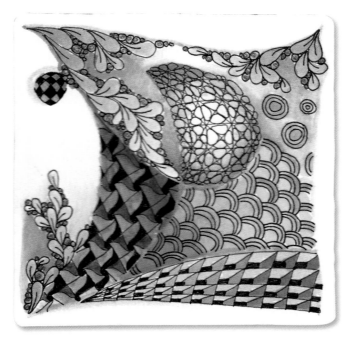

Knightsbridge

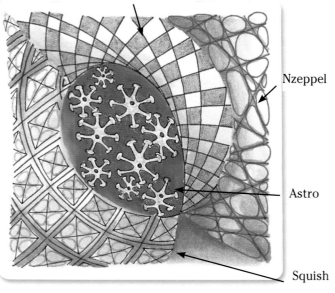

Nzeppel

Astro

Squish

Techniques: *Sakura* Micron black pen, Stardust Gel pens, Add colors with Dual Brush Markers using indirect coloring
Color Scheme: Blue and green Analogous

Astro

Jester

Techniques: Stamped image, *Sakura* Micron black pen. Add colors with Dual Brush Markers using direct coloring
Color Scheme: Blue and green Analogous

Astro - an original design by Debora Rohly, CZT

Astro was designed by a fellow CZT, Debora Rohly. Debora, and many other Certified Zentangle Teachers are available to teach amazing new tangles - check out the zentangle.com site for teachers near you!

Cadent

Cubine

 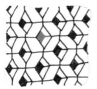 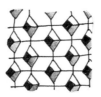

Tri Cube - a variation of Cubine

Techniques: Splash background, Micron black pen, Add colors with Markers using direct and indirect coloring
Color Scheme: Red and green Complementary

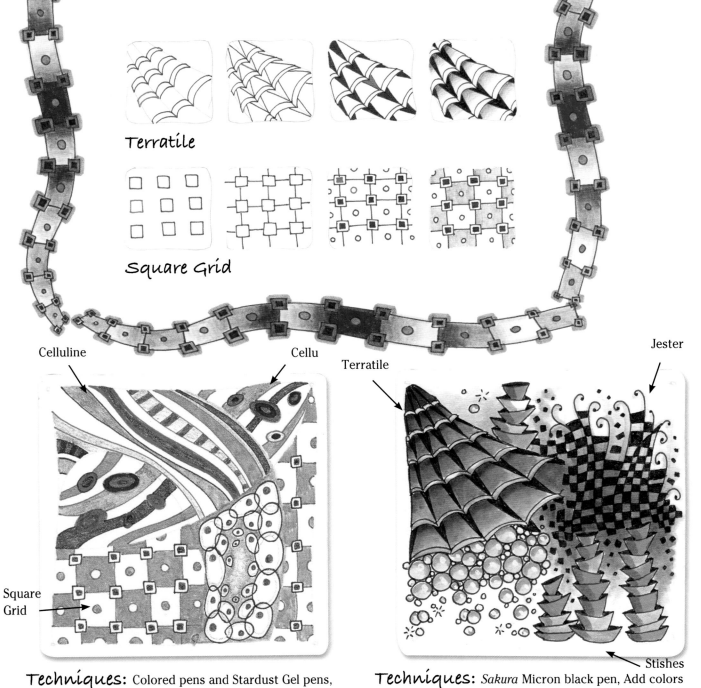

Terratile

Square Grid

Celluline

Cellu

Terratile

Jester

Square
Grid

Stishes

Techniques: Colored pens and Stardust Gel pens,
Add colors with Dual Brush Markers and direct shading

Color Scheme: Blue, purple and green

Techniques: *Sakura* Micron black pen, Add colors
with Dual Brush Markers using direct and indirect coloring

Color Scheme: Blue and brown

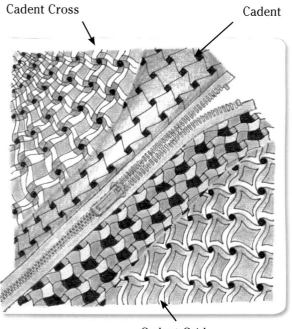

Cadent Cross

Cadent

Cadent Grid

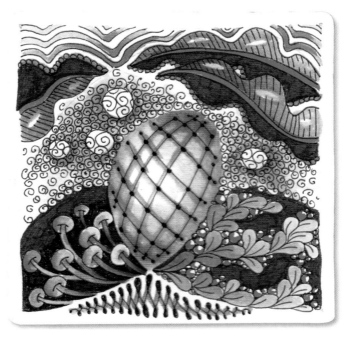

Techniques: Stamped image of a zipper
Sakura Micron black pen, Use colored pencils to shade

Color Scheme: Green and gold

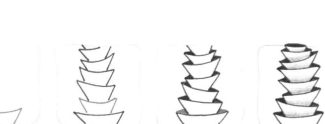

Stishes - You guessed it - inspired by stacked dishes!

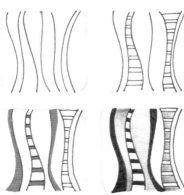

Celluline

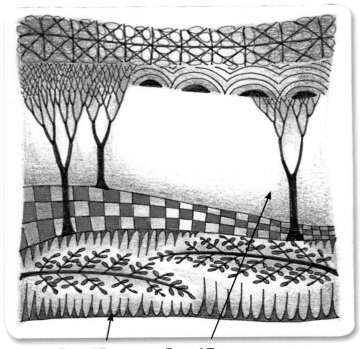

Fractal Shapes

A fractal is "a rough or fragmented shape that can be split into parts, each of which is (at least approximately) a reduced-size copy of the whole". The forms are self-similar at different degrees of magnification.

By changing the initial shape, you can easily vary this tangle!

Fractal Fern Fractal Tree

Techniques: *Sakura* Micron black pen, Micron color pens, Use colored pencils for shading

Color Scheme: Blue, olive green and purple

 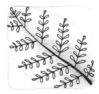

Fractal Fern

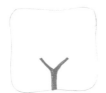 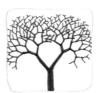

Fractal Tree

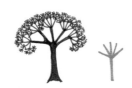

I was thrilled when I tried the fractal tree - I had never been able to draw a decent tree - now it's easy without even trying to draw!

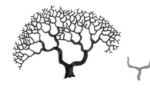

Even though they look complicated, Fractal Trees are very easy to create - just follow the fractal steps of repeating the same shape, each time a little smaller. As you add the 'Y' shape, you have already made the trunk of the Y, so just add the top V shape at each level.

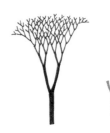

It's also better not to think about 'drawing' a tree, just let it happen!

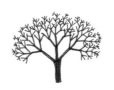

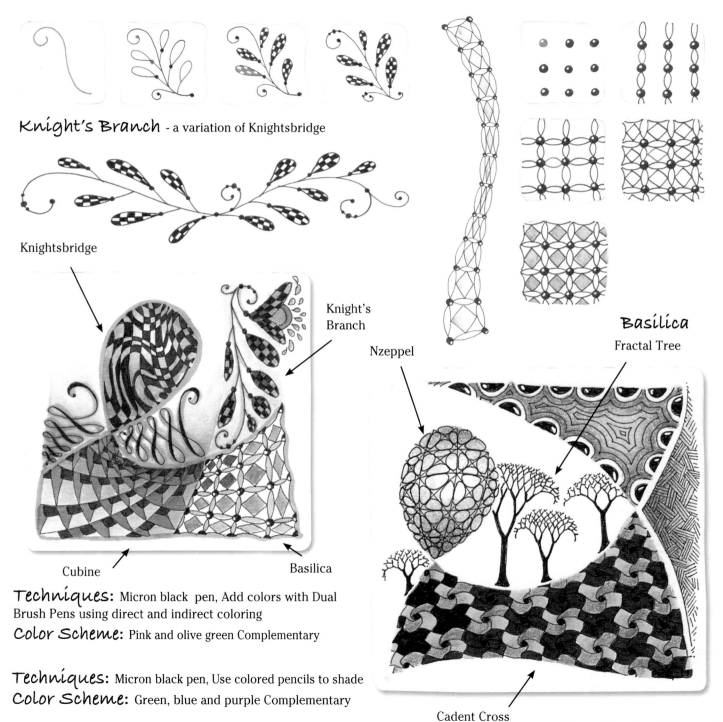

Knight's Branch - a variation of Knightsbridge

Knightsbridge

Knight's Branch

Nzeppel

Basilica

Fractal Tree

Cubine

Basilica

Techniques: Micron black pen, Add colors with Dual Brush Pens using direct and indirect coloring

Color Scheme: Pink and olive green Complementary

Techniques: Micron black pen, Use colored pencils to shade

Color Scheme: Green, blue and purple Complementary

Cadent Cross

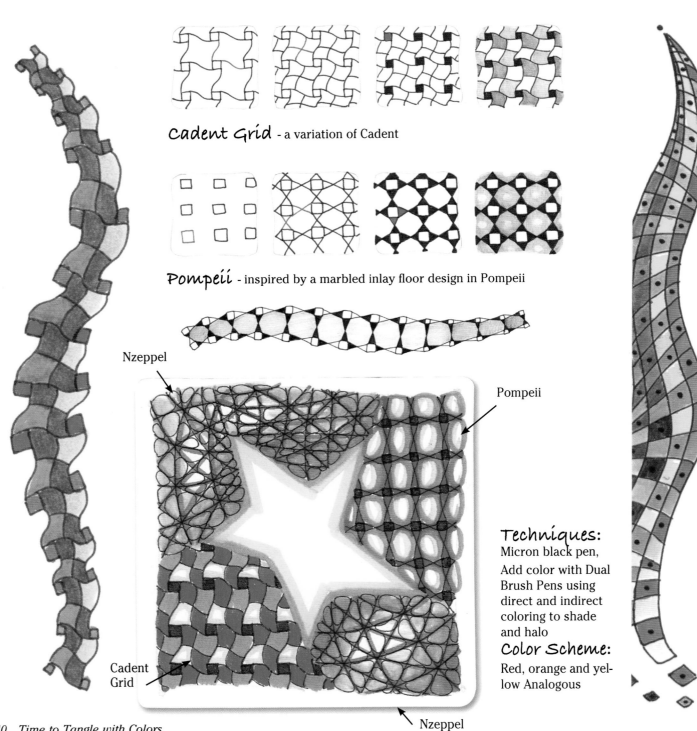

Cadent Grid - a variation of Cadent

Pompeii - inspired by a marbled inlay floor design in Pompeii

Nzeppel

Pompeii

Cadent Grid

Nzeppel

Techniques:
Micron black pen,
Add color with Dual
Brush Pens using
direct and indirect
coloring to shade
and halo

Color Scheme:
Red, orange and yel-
low Analogous

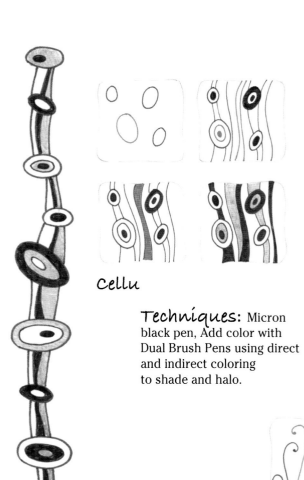

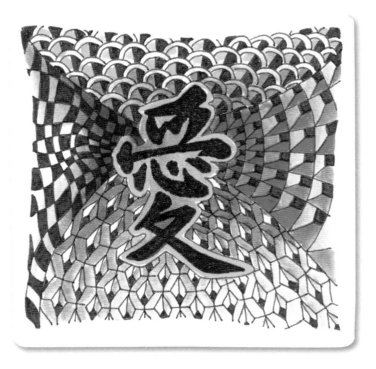

Cellu

Techniques: Micron black pen, Add color with Dual Brush Pens using direct and indirect coloring to shade and halo.

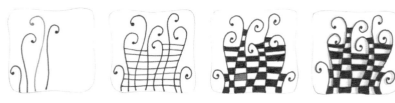

Jester - a variation of Knightsbridge

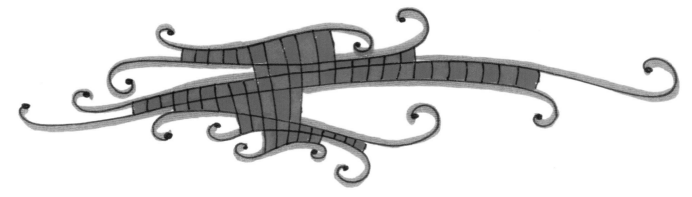

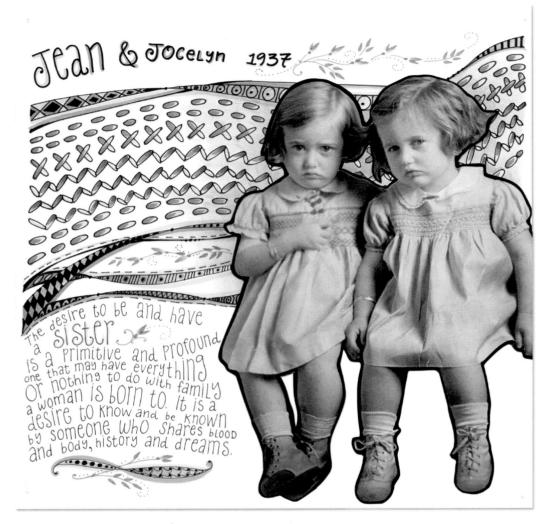

Jean & Jocelyn 1937

The desire to be and have a sister is a primitive and profound one that may have everything or nothing to do with family a woman is born to. It is a desire to know and be known by someone who shares blood and body, history and dreams.

Sisters Scrapbook Page

What a wonderful way to use old photographs! Scrapbooks tell a story, preserve memories, express hopes and put events in context. Journaling on this page ties the elements together and explains the purpose of the page.

The smocking on the little girls' dresses inspired the tangles on this page. Showcase vintage Black and White photographs with a blast of color. The roses and the sister poem give the page a soft, romantic sentiment.

Scrapbook Pages

Let photographs inspire your scrapbook pages. Choose colors from the photo.

Kayak Scrapbook Page

The blue Splash background was perfect for this kayaking photo. I chose colors that were in the photo. I decided to do the tangle patterns with a white Gel pen rather than a black pen.

Here's a hint for working with a white Gel pen: Draw slowly and keep the pen straight up and down to keep the ink flowing freely.

Be careful when coloring the tangles; do not go over the white lines. If you do, simply overdraw the lines.

Use a heavy piece of cardstock or watercolor paper for this page. Smooth 140# hp watercolor paper works well because it can tolerate getting wet without warping.

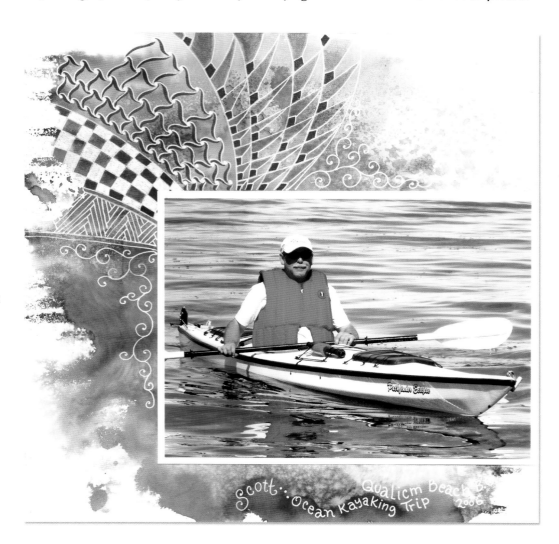

Create and
Send a
Personalized Card
to a Special
Friend or Relative.

↑ Cubine Combo X

Combine cool colors with the Cubine Tangle for excitement that flows and guides your eye around each area. Notice how the straight ribbons in the center taper at the bottom to create a sense of curve.

Checkered Rainbow

Dream on! Soft pastel coloring contrasts nicely with the black Micron pen. Note how the Knightsbridge checkerboard tangle is on both ends of the rainbow for more interest. →

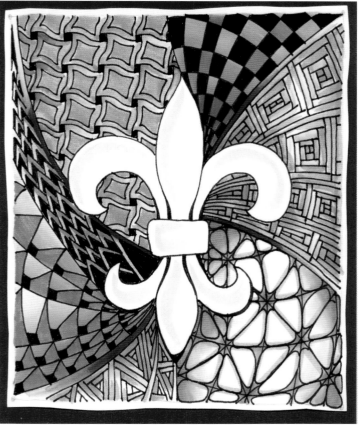

Greeting Cards

This tangle design was drawn on watercolor paper and mounted on a colored card blank.

The card was drawn with a black Micron pen and colored with Dual Brush pens.

Fleur de Lis Card

It's fun to include a string that outlines an object like a Fleur de Lis. Add a simple silhouette string and draw tangles around it to create this card.

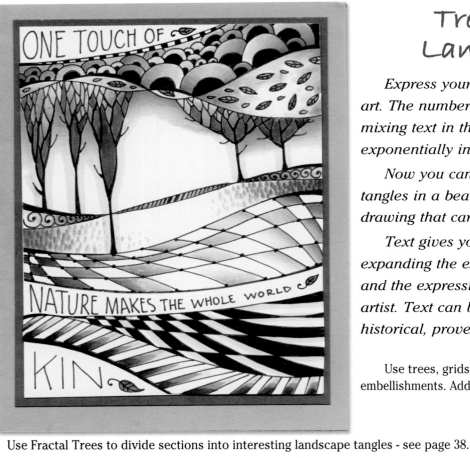

One touch of nature makes the whole world kin.

Trees and Landscapes

Express yourself with meaningful art. The number of artists who are mixing text in their designs has grown exponentially in the past 30 years.

Now you can combine text with tangles in a beautiful landscape drawing that carries a message.

Text gives your art a voice, expanding the experience of the viewer and the expressive opportunities of the artist. Text can be intimately personal, historical, proverbial, or observational.

Use trees, grids and tangles as fillers and embellishments. Add color with Dual Brush markers.

Use Fractal Trees to divide sections into interesting landscape tangles - see page 38.

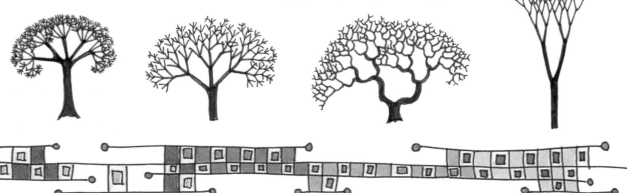

Photo Frames

Focusing your attention on the loved one in the photo will help you choose tangles that reflect your appreciation for their unique qualities.

Color Chart

725
723
245

Signatures

Signing your finished art is very important. Decorate your name and signature.

Marie Browning

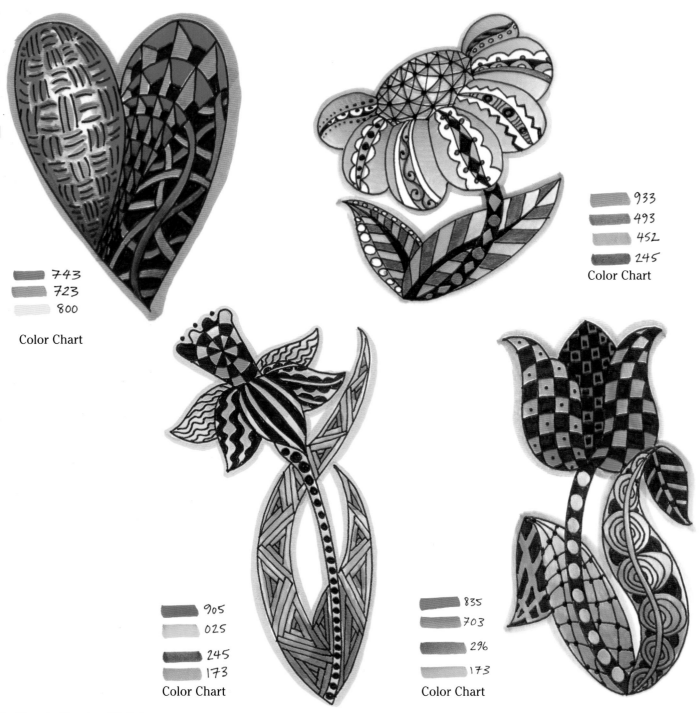

743
723
800

Color Chart

933
493
452
245

Color Chart

905
025
245
173

Color Chart

835
703
296
173

Color Chart

Tangled Images

Nature drew tangles on dragonfly wings and designed delicate veins on leaves. Follow her example. Simply view the sections of your image as art to be tangled and let your creativity soar.

Sometimes it is fun to use creative colors when creating the patterns, such as pink bumblebees with green wings.

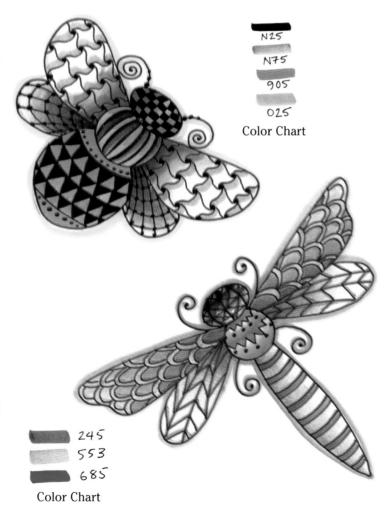

277
173
493
553
Color Chart

N25
N75
905
025
Color Chart

249
098
Color Chart

245
553
685
Color Chart

48 Fun Tangle and Border Patterns...

Knightsbridge
page 26

Knightsbridge
Border

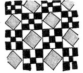
Knight's Tri
page 27

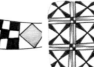
Knight's Tri
Border

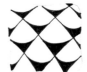
Knight's Cross
page 27

Sag
page 29

Sag
Border

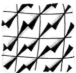
Strike
page 29

Strike
Border

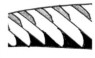
Feagle
page 29

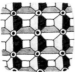
Feagle
Border

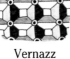
Vernazz
page 30

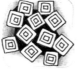
Skistel
page 30

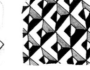
Skistel
Border

Mod Box
page 31

Inlay
page 31

Cadent
page 31

Cadent
Border

Cubine
page 32

Squish
page 32

Squish
Border

Germie
page 33

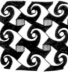
Cadent Swirl
page 33

Cadent Swirl
Border

Scroll
page 33

Cadent Cross
page 34

Nzeppel
page 34

Nzeppel
Border

Astro
page 35

Astro
Border

Tri Cube
page 35

Terratile
page 36

Square Grid
page 36

Square Grid
Border

Stishes
page 37

Stishes
Border

Celluline
page 37

Fractal Fern
page 38

Fractal Tree
page 38

Knight's Branch
page 39

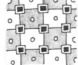
Basilica
page 39

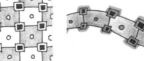
Basilica
Border

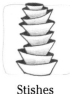
Cadent Grid
page 40

Cadent Grid
Border

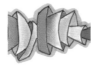
Pompeii
page 40

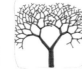
Cellu
page 41

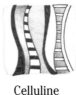
Jester
page 41

Jester
Border